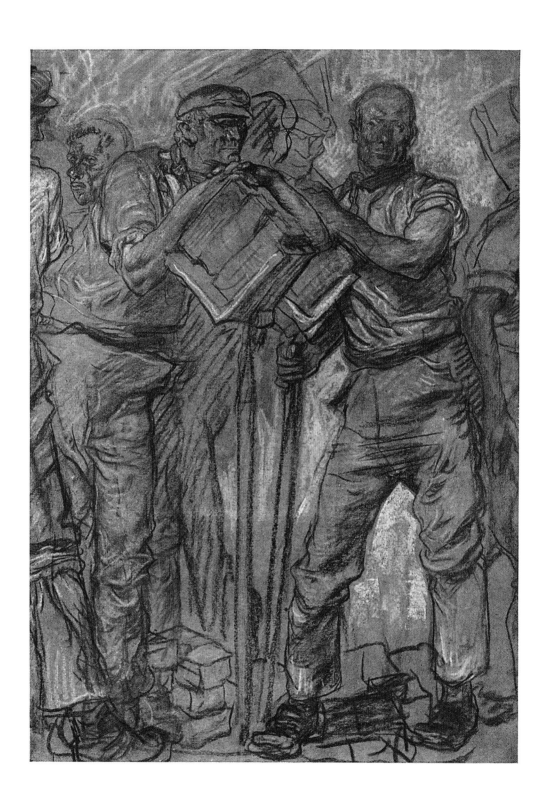

THE ART OF
Painting in Pastel

LEONARD RICHMOND
AND
J. LITTLEJOHNS

Introduction by

FRANK BRANGWYN

DOVER PUBLICATIONS, INC.
Mineola, New York

Bibliographical Note

This Dover edition, first published in 2017, is a slightly altered, unabridged republication of the work originally published by Sir Isaac Pitman & Sons, Ltd., London, c. 1917. Please note that some of the materials mentioned are outdated and are no longer available on the market.

Library of Congress Cataloging-in-Publication Data

Names: Richmond, Leonard, author. | Littlejohns, J. (John), 1874–1955, author. | Brangwyn, Frank, 1867–1956, writer of introduction.
Title: The art of painting in pastel / Leonard Richmond and J. Littlejohns ; introduction by Frank Brangwyn.
Description: Mineola, New York : Dover Publications, Inc., 2017. | "This Dover edition, first published in 2017, is a slightly altered, unabridged republication of the work originally published by Sir Isaac Pitman & Sons, Ltd., London, c. 1917."
Identifiers: LCCN 2016040735| ISBN 9780486814216 | ISBN 0486814211
Subjects: LCSH: Pastel drawing—Technique.
Classification: LCC NC880 .R5 2017 | DDC 741.2/35—dc23 LC record available at https://lccn.loc.gov/2016040735

Manufactured in China by LSC Communications
81421101 2017
www.doverpublications.com

INTRODUCTION.

THE mention of the word " Pastel " usually conjures up the eighteenth century, with visions of pretty faces, portraits of women and children, done in that medium by Rosalba Carriera; or, maybe, the more manly work of La Tour ; or, again, the nervous touch of Perronneau's hand. To one more intimately acquainted with the art, the marvellous pastels with which Chardin, late in life, suddenly surprised his contemporaries, will stand out as by far the most remarkable achievements of that period. Chardin, in his own portraits and in that of his wife, actually forestalled the method of visualisation which we to-day associate with one phase of so-called Impressionism : he broke up light and shade into touches of pure colour the juxtaposition of which gave the appearance of things seen in ambient atmosphere. This is in fact the precise achievement of modern impressionistic visualisation, and hence, since the latter part of the nineteenth century, the art of painting in pastel, *i.e.*, with dry colours applied usually to paper, has been employed with much success in landscape painting.

It is, therefore, a mistake to think that pastel is suited to the rendering only of the soft delicacy which we associate with the beauty of women and children ; on the contrary, there is, as Messrs. Richmond and Littlejohns so ably point out in the following pages, practically no limit to its powers as a means of artistic expression.

Pastel painting has also certain practical advantages which specially appeal to the artist. For, unlike water-colour and oil painting, it can be taken up and set down at any moment without any untoward result. Its practice presents, furthermore, few technical difficulties. This statement, however, must be understood in the proper sense. Pastel painting, *i.e.*, the application of *dry* colour to the ground, possesses as it were a language, or, better expressed, a dialect, of its own and quite distinct

from the dialect of oil or water-colour technique. Each branch of the painter's craft has its own mode of expression, its own form of utterance, and to attempt to imitate the appearance of one branch by the means of another is to court failure.

As a means of sketching from life and nature Pastel is unrivalled. Not only can a few touches of colour deftly applied to a monochrome drawing heighten the effect and increase its decorative value, but even the fleeting atmospheric changes on the face of nature may be retained and recorded by this technically simpler method, requiring none of the paraphernalia of oil and water-colour painting.

The following pages will show the student the great advantages pastel painting has to offer : the absence of many technical difficulties, the ease with which he can take his few sticks of pastel and sheets of paper with him on his walks abroad, and the quickness with which he can get ready to take " notes."

The authors very justly emphasize the fact that, the more simply a thing is treated in pastel, the better is the result—a maxim which really applies to all works of art. One of the greatest difficulties the artist has to cope with is the finding of the simplest means by which to express the subtleties he, in virtue of his vocation, sees and realises in nature.

CONTENTS.

BLACK AND WHITE ILLUSTRATIONS.

COLOURED ILLUSTRATIONS.

"BRICKLAYERS," BY FRANK BRANGWYN, A.R.A.—*Frontispiece*

STILL LIFE.

FLOWERS.

LANDSCAPE.

FIGURE.

PAINTING IN PASTEL.

CHAPTER I.

THE THREE METHODS.

BROADLY speaking, there are three methods of using pastel. The first is to rub on a little of the material and then smear it all over the surface, adding touches and lines on the top of the smeared background. The second is to work completely in strokes, either with the point or with the side of the pastel, layer over layer, pressing it in so that the top layer is modified by that immediately underneath. The third is to lay the strokes side by side more or less lightly, so that the paper shows through.

Now, in deciding the relative merits of these three methods, we must first understand the great principle governing the use of all mediums. It is this : that every medium should be used in the way for which it is most naturally adapted ; that its limitations should be frankly recognised, and its characteristic qualities emphasized rather than obscured. The distinguishing feature of oils is that they can be used in varying thicknesses in one picture by varying the proportion of oil to pigment. The distinguishing feature of water-colour is its transparency. The distinguishing feature of pastel is its loose, dry, crumbling quality.

A pastel should not look like an oil or a water-colour, as if it were ashamed of its origin ; there should be no doubt, from the first glance, that it was done with pieces of coloured chalk.

Judged by this test the third method is undoubtedly superior to the other two. The first method, at one time almost universal and still most in vogue, is responsible for most of the trivial prettiness and mechanical smoothness with which pastel has come to be associated. The general effect is that of a laboured water-colour devoid of every touch of spontaneity. At the same time, it must be acknowledged that, when it is used with discretion, very beautiful results have been achieved. The work of La Tour and others of the French pastellists of the eighteenth

century will serve to illustrate this point. It would be absurd, therefore, to say that pastel should never be rubbed; but the method is dangerous, seldom necessary, and demands the utmost reserve.

The second method is nearly as prevalent as the first. One often sees pictures with a thick layer all over the surface, and the chalk falls off constantly at every movement. This is the type of work that has produced the popular prejudice that pastels are not permanent. The general effect is that of a painfully worked up oil painting, altogether uninspiring and completely disregarding the characteristics of the material. But here, again, it is impossible to condemn the method entirely because it is usually carried to excess. If every colour had to be laid alongside and never over another, then, either an enormous selection of pastels would be required, or else the possibilities of the material would be unnecessarily limited. The great point always to keep in mind is that the second colour should be laid lightly and loosely *on* the first, allowing the first to show through and the paper to show through both, instead of being pressed *into* the other so that they become mixed and the surface of the paper is entirely hidden.

The third method is the one which brings out the best qualities of pastel—its brilliance and power no less than its subtlety and suggestiveness. There is, too, in the ease and simplicity of this method, a constant sense of mastery produced by the evident economy of means to the accomplished end. The beginner will be astonished to find how much can be done with a few pastels, varying degrees of pressure, and a suitably chosen paper. And as the student's control over the medium increases, he will be assured of the absurdity of the prevalent idea that pastel is fitted only for light and airy suggestion; he will soon realise that there are practically no limits to its powers of artistic expression.

CHAPTER II.

STILL LIFE.

STILL life is a subject that could be treated with advantage by most artists more often than is usually the case.

To obtain a successful result, there must be no shirking difficulties or hiding bad drawing, for it is a condition of the kind of representation known as " still life " that all the objects are represented in the foreground, and, therefore, close to the spectator.

Pastel, being essentially a medium in which drawing and colouring work well together—a medium whose nature is appropriate to the structure or shape of the thing represented—is well adapted for still life studies.

The student who wishes to take up landscape sketching would be well advised to make many careful studies of still life, as it is of great assistance in learning how to manipulate pastels.

The handling of this medium is not so easily acquired out of doors, where the artist has a good deal to contend with, such as a strong wind, a scorching sun, and irritating flies; but, indoors, the mind can be concentrated on the technique or style in which the various objects may be depicted.

Keep your work as fresh and simple as possible. Avoid over-labouring the pastels. If you discover that your picture has become dull and smudgy through your inability to get the right result, it is much better to begin again than to be continually striving to make wrong right—a proceeding certain to end in failure. One of the most characteristic things about successful pastel is its bright, direct, and spontaneous charm.

Pastel will reproduce many surface textures.

For instance : A coarse piece of serge or sacking cloth could be placed in contrast with a smooth china jug. In rendering the rough cloth, the pastel should be used firmly and boldly, yet so as to get the tone of the paper to help as well, judiciously allowing patches of it to appear at little intervals ; this should be the means of producing a coarse, fibrous type of surface.

In doing a china jug, the pastel might with advantage be rubbed gently in places with the finger, so as to get a smoother surface ; though

great care should be exercised not to overdo this, as otherwise it would have a tendency to become dull and unsatisfactory. Any bright reflected lights could now be done on this prepared surface.

In the first stage of a picture always keep your colours *flat*. Do not attempt to model surfaces until the later stages. General tone values come first. To introduce two tints of the same colour on one subject, before the whole scheme or foundation of the picture is laid in, is likely to upset the unity or breadth of the subject represented. In any case it would create unnecessary difficulties.

Quick experiments on odd pieces of paper are very helpful to the student who is not quite sure whether or not he is obtaining the best possible results.

THE PLATES

BLUE CHINA POT, SHELL, ETC.

PLATE I.

This group consisted of a blue china pot, a large sea-shell, two bright yellow tulips, a gold chain with a little pendant of blue stones; dark brown panelled background. Paper used, grey.

First Stage.—Strong definite outline in dark brown or black pastel was used in the first instance. Blue pastel for the pattern on the china pot, treated in a flat manner, and the same colour for the blue stones. Lemon yellow for that part of the two flowers reflecting the light, using the tone of the paper for the shade of the flowers. Dark brown pastel for the background, and a little brownish grey for the sea-shell.

Second Stage.—The light coming from the left side of the picture emphasizes the left side of the objects depicted. Lighter blue was therefore used for the pattern of the vase in the light ; white and yellow for the highest light on the flowers; and bright emerald green, rose madder, white, and cobalt blue to get the effect of the mother-of-pearl shimmer on the sea-shell. Light gold yellow and light blue for the china and blue stone respectively. The last step was to represent the shadows thrown by the various objects.

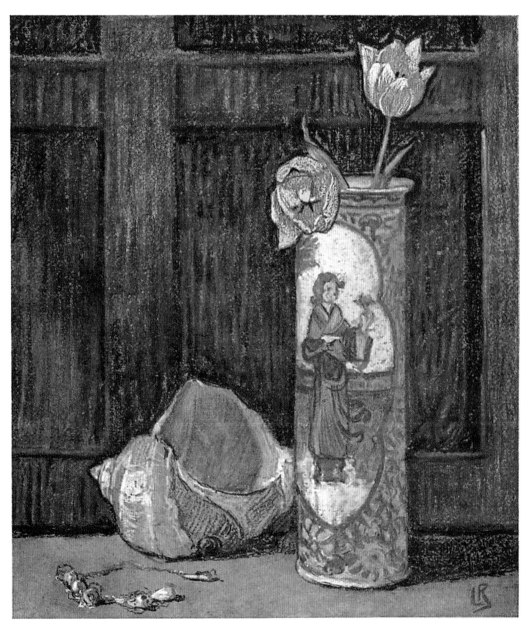

PLATE I.

JUG, GLASS, AND APPLES.

PLATE II.

This group was composed of a large jug or pitcher, a glass tumbler, and some apples on a table, with an oval picture in a gold frame in the background. Paper used, brown.

First Stage.—Outlined as before with dark pastel. A medium-coloured blue (leaving room for other pastels) was used for the wall, with delicate touches of deep gold for the picture frame. For the portrait of a Puritan, burnt sienna and light grey were employed, with very dark brown for the clothing. The colour of the jug was obtained by burnt sienna, ultramarine, and dark brown; the colour of the apples by crimson and yellowish green.

The glass tumbler being transparent, the colour of the background was mostly used. The foreground consisted of burnt sienna and deep gold, but not used excessively, so that the local colour of the paper might have a chance of assisting in the production of the correct depth of tone.

Second Stage.—Light purple, a little light yellow ochre, and grey were used for the background, so as to intermix with the first colour, blue; and yellow ochre, white, and grey for the portrait. The deeper shadows of the picture frame, jug, glass, tumbler, table, and apples were then indicated, concluding with the high lights on the same objects.

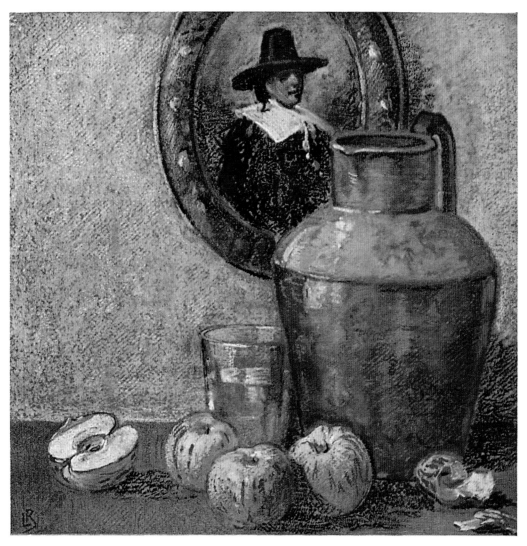

PLATE II.

DOLLS, MONKEY, AND GOLLIWOG.

PLATE III.

This picture was chosen as a novelty in still life. It is surprising that toys are so seldom exploited. They can be made very amusing and are nearly always interesting in colour.

The curtains or cloth hangings behind the dolls helped the composition of the picture, and prevented the doll on the right-hand side from being too much detached from the rest of the group.

The pattern on the lighter curtain adds interest and variety to the background without destroying the unity of the picture. Paper used, brown.

First Stage.—Grey was used for the wall, yellow for the curtain, dark green for the curtain on the right-hand side, vermilion, rose madder, and bright blue for the stripes of the dolls, etc. Purple was sparingly applied for the foreground, and burnt sienna for the faces and legs of the dolls. The hair of the dolls and the face of the golliwog are jet-black and dark brown respectively. Burnt sienna was used for the monkey.

Second Stage.—Light yellow ochre, green, and red were used for the walls and one curtain; lighter green and black for the other curtain; light yellow and white to strengthen the light on the dolls' clothes and shoes; light blue and light orange to brighten the effect of the striped clothes; and pale rose madder for the high light on the monkey's coat. Warm yellow was used to strengthen the lighter parts of the monkey's arm, head, and legs.

10

PLATE III.

BOOKS, BOWL, AND FLOWERS.

PLATE IV.

This group consisted of books, bowl, and flowers, with a picture hanging on the wall behind. Paper used, **brown**.

Various books with different-coloured covers always form an attractive feature. A few chrysanthemums were introduced to make a bright contrast to the books and the dark background.

In designing the arrangement of a still life group, the student must remember that, besides the agreeable placing of the objects, the relative position of the various colours is equally, if not more, important.

Bright colour, whether it is good or bad, directly attracts the eye. Too much bright colour placed on one side of a picture, the other side being left destitute of the same, will in most instances spoil the balance or general design of a picture. Instead of having five chrysanthemums in the bowl, one was put on the left side of the group, thus leading the eye to another part of the picture through the medium of the same colour as that of a flower in the bowl.

First Stage.—Dark brown was used for the background; a flat tint of bright blue, red, purple, orange, and grey for the different books and prints; light grey, carmine, viridian, and vermilion for the bowl. The leaves were done in dark green pastel, and the chrysanthemums had a foundation chiefly of deep orange and light red. The foreground or table required deep crimson pastel.

Second Stage.—Lighter tints of the same colours as were used in the first stage were used now: lemon yellow and white for the flowers; yellow ochre, white, and light grey for the lighter portion of the bowl; and grey, white, and yellow for the picture in the background. Grey was also used in several places to sober down some of the more pronounced colours, and incidentally it helped to create a sensation of atmosphere.

The shadows caused by the various objects were mostly done with the background colour.

12

PLATE IV.

CHAPTER III.

FLOWERS.

FLOWER painting is commonly regarded, by artists and public alike, as something easy and elementary as compared with landscape and figure painting. It is true that a flower is easier to copy than a landscape or a face, but the fact remains that, for every dozen artists who can successfully paint a landscape or a figure subject, not one can paint an equally successful flower picture. It is simple enough to reproduce the shape and colour of a flower, but it is quite another matter to reveal its beauty. Let no one, therefore, who essays to be a flower painter imagine he has set himself a light task.

Preliminary studies, naturally, will be of a single flower. Take something simple in shape, that can be easily rendered in pastel. A large white ox-eye daisy will do very well. Choose a grey paper, slightly darker than the darkest parts of the petals in shade, but lighter than the darkest parts of the stems.

Begin by " blocking in " the general shape of the flower. It is fatal to commence by making a detailed drawing of every petal, because the inevitable result will be that the petals will be too small and too much separated from one another. If looked at with eyes nearly closed, it will be seen that the parts in light and the parts in shade form pretty definite masses. Draw the general shape of these masses.

Now choose a pastel which, when used lightly, will, with the aid of the paper showing through, give the general tone of the parts in shade. Cover all these parts with strokes going in the same direction as the petals. Then choose a nearly white pastel, and do the same with the light masses, varying the pressure according to the tone required. When this is done, emphasize the high lights with a very pale pastel inclining to yellow, and in the same way use a darker and colder one (but not so dark as the paper) for the darkest shadows. The yellow centre will need only two pastels—a bright yellow, and a darker one inclining to green or perhaps brown ; varying pressure will do the rest.

This method will not give an exact copy, because the varieties of tone and colour in any white flower are endless. But the effect will be a

15

great deal more suggestive and satisfying than any attempt at absolute realism at this stage.

For the next study, add another grey to render the warmer parts of the shadow where the light shines slightly through; but always remember that it is better to err on the side of simplicity than on that of over-elaboration.

The following notes, appended to the illustrations in this chapter, refer for the most part to principles of treatment, and do not give detailed technical instructions. But the student who has benefited by a careful study of the still life groups illustrated in the previous chapter, and has set up and copied groups on similar lines, should not need to be told what colours to use.

WHITE MARGUERITES.

PLATE V.

A group of daisies done in exactly the same manner as explained on page 15. Note how the group is arranged: all the flowers are in different positions, to lend variety to the group; prominence is given to the stems on account of their interesting shape; attention is concentrated on one large blossom by placing it in full light, while those of least importance are almost entirely in shade.

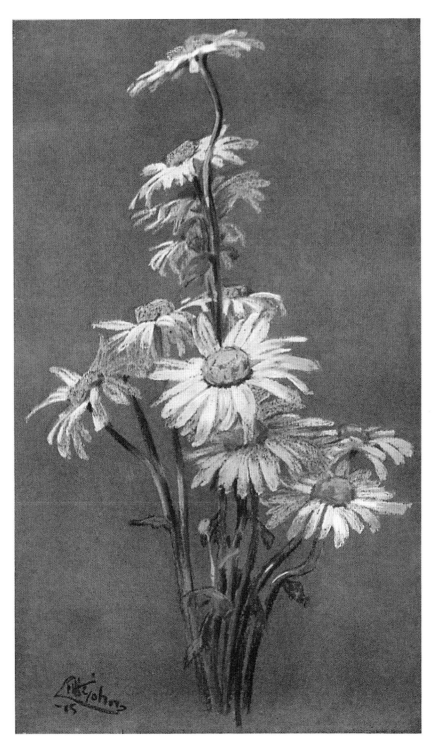

PLATE V.

BLUE CORNFLOWERS.

PLATE VI.

These flowers are of a quite different character, requiring quite different treatment. A single specimen is not of much artistic interest, but the mass, when the detail is indistinguishable, is delightful in colour.

The only way to treat it, therefore, is as a mass of colour, mainly blue and purple. A little of the construction of the individual flowers is plainly evident here and there, generally at the centre and the edges, but the less detail shown the better; the shape, colour, and character of the whole is the thing to aim at. In order that the mass may show distinctly, a paper considerably lighter in tone has been used.

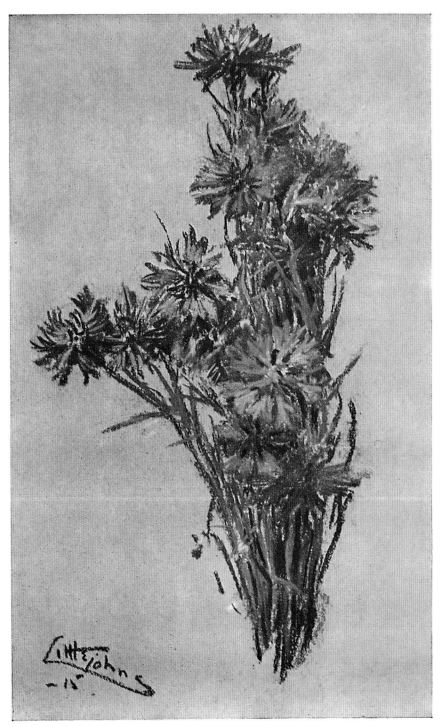

PLATE VI.

SCARLET POPPIES.

PLATE VII.

The main purpose of this example is to indicate the importance of the toned paper as a modifying factor.

The strongest crimsons and vermilions were used unsparingly, but the result is not garish, because of the counteracting influence of the dull, dark paper left between most of the strokes—less in the brighter parts than in the shadows.

Note that, while the general contour of each petal is curved, the strokes are frankly straight, serving to give that crispness which is so characteristic of this flower.

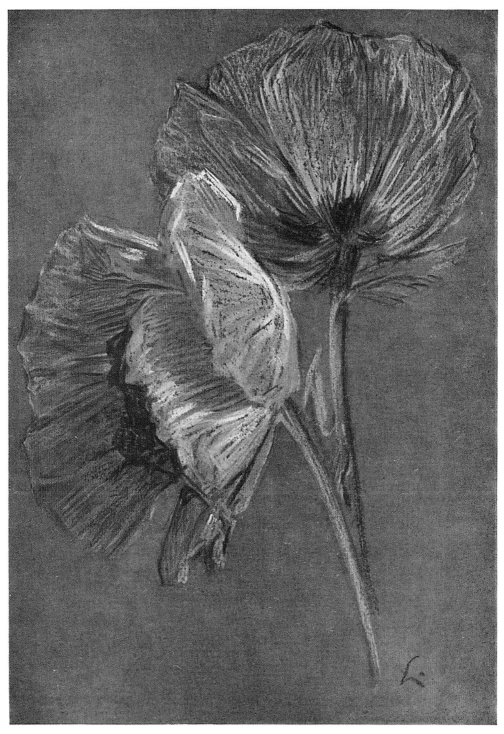

PLATE VII.

HYDRANGEAS

WITH

A PLAIN BACKGROUND.

PLATE VIII.

All the foregoing examples are only studies for picture-making. This plate is a composition of which flowers form the most prominent feature. The arrangement is of the simplest character, the colour of the dark paper being utilised to the full. The polished table is merely suggested by a few reflections. The treatment of the vase is rather slight —just enough to indicate its shape, general tone, and colour. In the flowers there is no display of botanical knowledge or slavish inclusion of unnecessary details. Attention is chiefly directed to their mass and colour, and to the effect of light upon them. But on two or three of the most important ones a considerable amount of detail has been lavished in order to create a special point of interest.

The little Japanese bowl serves three purposes : it breaks the long, even line of the flower bowl ; it gives interest to a part of the picture that otherwise would look empty and tame ; and it repeats nearly all the colours of the picture on a rather brighter scale.

22

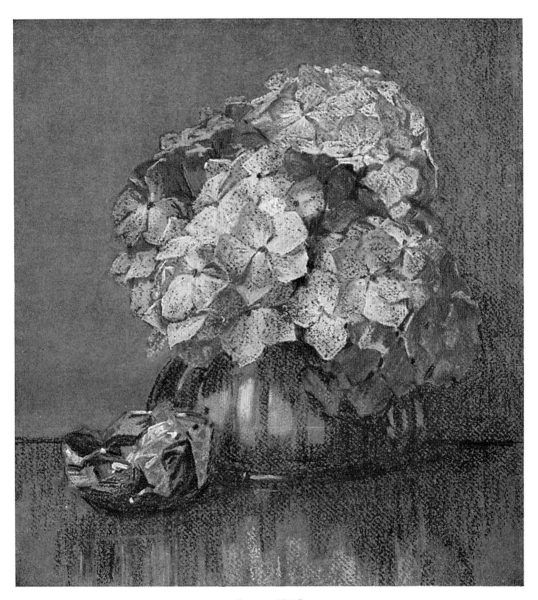

PLATE VIII.

HYDRANGEAS

WITH

AN ORNATE BACKGROUND.

PLATE IX.

This shows the same kind of flower in a more ornate setting. A dark green paper was chosen so that a considerable amount of the surface could be left untouched when treating the curtain. An undertone of varying greys was rubbed in all over the flowers. The observations regarding PLATE VI apply equally here. It is the mass that is most important, not the separate flowers. But the most important consideration, viz., the relation of the flowers to the background, cannot be laid down dogmatically, because it is dependent upon the individual taste and aim of the artist. He may desire to make the flowers stand off in strong contrast to a vague background. On the other hand, delightful effects can be obtained by making both of equal importance, regarding the whole picture as a decoration. This illustration leans decidedly towards the latter idea.

CHAPTER IV.

LANDSCAPE.

It is only within the last twenty years or so that pastel has seriously been taken up by artists as a medium for finished landscapes. Before that time, figure work had been more successful, and artists had not clearly realised the possibilities of the medium in other directions.

The characteristic charm and strength of pastel have been woefully abused in many instances, the finished picture looking almost as if it had been executed in oil or water-colour. It is sometimes necessary to go very close to a picture before discovering that it was done in pastel. This unfortunate result is mainly brought about by the use of a paper with a surface resembling sand-paper, on which one colour has been laid on top of another until the surface resembles a solid piece of oil painting on a rough canvas.

In the expression of ideas, every medium has its own particular use, and pastel is far too interesting in its own sphere for any artist to wish to make a picture in pastel look like an oil or water-colour.

In this chapter, therefore, too much stress cannot be laid on the importance of fully realising the legitimate use of pastel. It must be borne in mind that it is coloured chalk, that the tone of the paper should help the chalk, and *vice versâ*, and that the simplest handling usually obtains the most direct and the best results.

It is particularly suited for recording quick transitory effects in out-door sketching, and, further, it is a medium by which the close observer of nature is enabled to record sudden displays of light on undulating country or on the surface of the sea, clouds moving rapidly during a gale, twilight effects, etc.

In other mediums, as a rule, there is little chance of getting such effects at the moment, because of the limitations of the material used.

Avoid, in the initial attempts at landscape sketching, the use of too many different pastels. It is a common sight to see an art student, with a box containing from a hundred and fifty to two hundred pastels of varying shades and colours, trying to negotiate some difficult passage in landscape sketching, and quite bewildered and overwhelmed by the large number of pastels in his box. A great variety of artistic

effect can be achieved with from four to six pastels. As experience ripens, you will gradually have more pastels in your box, without the risk of impairing the unity of your picture.

It is advisable to begin outdoor sketching with the cool brown paper mentioned in Chapter IX. Its surface is fairly smooth, and this smoothness allows the pastel to glide rapidly and cover the ground easily, thus saving considerable time—generally an important item in sketching.

A rough surface has a tendency with some artists to give a woolly appearance to the finished result, and it also requires more labour to cover the ground. The brilliancy and purity of a pastel show at once on a smooth surface. The rougher paper is sometimes useful for misty, delicate sketches such as may be seen on a November day in London, or for early morning effects in the country. A point to remember always is that tinted paper represents tone and shadow, and naturally directs the artist's attention, at the beginning of a sketch, to the representation of light. Therefore it follows that the sky, in most cases, will be the first thing to be suggested in the sketch, and this will be the means of strongly emphasizing the earth against the light of the sky. Also the composition of the picture is at once made clear—for good or bad, as the case may be.

If a student should discover during the progress of a sketch that a certain colour is too crude or garish, the defect can instantly be remedied by adding here and there a light pressure of grey pastel, on the surface, or by the side, of the offending colour. In fact, a light grey put in places or spots with, say, a brilliant greenish yellow, helps to emphasize the latter colour and to create a sensation of atmosphere and refinement, which is not always so easily obtained with the use of one colour only.

The student who takes up pastel sketching to any extent should experiment as much as possible. There is plenty to discover. Each different-toned paper opens up fresh problems; e.g., grey paper needs scarcely any grey pastel at all (if any).

We will now deal with actual sketching. It is wiser for the inexperienced to adopt some plan or method in setting about their work.

I will take it for granted that you wish to sketch an ordinary landscape subject, such as fields, trees, water and sky, a building or two, and a few small clouds.

The sketch, done on cool brown paper, can be taken in four

LANDSCAPE.

stages, four pastels only being used, viz., black, light yellow ochre, grey, and white. Two or three minutes should be quite long enough to suggest a few leading lines, as most of the drawing will be done during the later growth of the sketch.

First Stage.—For the sky, take the yellow pastel from about half an inch to one inch in length, and use it perfectly flat. Do not press heavily; move the pastel about in all directions (a slow movement is generally lacking in spontaneity and lightness), with occasionally a vertical stroke to give a feeling of height or contrast. Do not cover up every particle of the paper with this colour; leave room for one or two other pastels to be used in conjunction with the yellow ochre.

Second Stage.—Use the black pastel for the outlines of almost everything in the foreground, such as trees, houses, fields, etc. Do not make the outline too rigid or like a piece of black rope, hemming everything in without the chance of escaping. Notice how the outline brings objects to the front of the picture without the aid of colour or aerial perspective. The chief idea of an outline is that in the earlier part of a drawing the main scheme of a sketch should be kept prominently in the student's mind. An outline is, with advantage, sometimes lost in the finished sketch, but sometimes retained; it depends upon the nature of the subject selected and the temperament of the artist. A thick solid line around trees, houses, etc., is a really good tonic for a student whose work is apt to look either weak or insipidly pretty. There are times when a drastic measure has brought beneficial results. To relieve the flatness of the foreground trees, deepen the shadows, and add some shading to the fields (well in the foreground) if necessary. Trees, being darker in tone than pasture, will require more of the darker pastel. At this stage your drawing should have strength and solidity. The tone of the paper will give unity to the whole picture.

Third Stage.—Grey will then be used to advantage for clouds in shadow, roads or pathways, white buildings in shadow, and may be very delicately and sparingly applied for distant hills.

Fourth Stage.—The sketch being now nearly completed, we can use the last, but sometimes dangerous pastel, white. Use but little and that lightly. Apply it to the portion of a cloud that catches the light. It could also be used in the sky nearest the sun, where a graduated light is often seen in nature. Do not lay it on thickly or it will defeat its own purpose, producing a chalky instead of an atmospheric, vibrating light.

PAINTING IN PASTEL.

In sketching from nature, too much time is often wasted by people who, being keen on finding a good composition, wander about in all directions, and frequently spend an hour, or even longer, without getting anything very satisfactory from the pictorial standpoint.

Is it material even if we do fail to find perfect compositions out of doors ? Nature is bountiful in furnishing us with supplies of ingredients, which we can utilise as they present themselves, or select at pleasure ; and afterwards, from a number of outdoor studies, we can evolve a picture. Why not get a scheme for a picture indoors, and then go to nature for the various parts ? The poet, like the pictorial artist, has nature at his disposal, and his genius assimilates nature in order to interpret it according to his temperament.

In the not very remote past, many artists have been so hampered by the details of nature that any individuality they may have possessed has been almost submerged.

If the function of landscape painting is just to please certain people who know little of art or nature, to record pretty scenes, to give to the world a charming picture which is easily forgotten, to imitate solely and entirely the exterior aspect of nature, then surely it would be better to drop the subject altogether.

To make studies of nature and pictures of nature are two quite different things. Both are essential for the would-be landscape artist. The student who is familiar with the shape, the structure, and the colour of a hundred and one different things seen in landscapes is obviously better equipped than one who has neglected to make such studies.

Studies of detailed portions of nature should be used as notes for the great idea; *i.e.*, the picture. There are some pictures described as landscapes, where many clever nature notes are put together, each fighting for possession, and competing one against another, instead of helping to illustrate a definite idea and being subordinate to that idea.

The personality of the artist should be strong enough to eliminate what is unnecessary for the purpose of making a picture.

CHAPTER V.

LANDSCAPE (*continued*).

PRELIMINARY EXERCISES.

IN the landscape section of this book there are numerous drawings of trees in the foreground and distance.

It would be a good thing for the student, at this stage, to realise the simple and effective manner in which masses, or groups of trees, buildings, skies, etc., can be shown on dark-toned paper in a very short time with a minimum of effort.

It does not matter whether the subject is complicated or simple, the tone of the paper will pull the whole sketch together. The same colour (viz., that of the paper), constantly occurring, links up various passages of light and shadow, trees and sky, buildings, pathways, and other landscape items, giving a unity to everything that may be contained in the picture. This can easily be proved by trying to get the same effect on white paper, where the tones of the different landscape objects have to be built up, whereas a brown or grey paper would have been of assistance from the starting-point.

The value of the tint of the paper is negatived if the pastel is laid on so thickly in every part of the sketch that the colour of the foundation is hidden. A good rule to follow is to use the pastel required for shadows very thinly and lightly. This should cause the shadow to look transparent and elusive. There are instances where the tone of the paper is just right in depth for the shadow required, and no pastel, of course, need then be used for it.

AN ELM.

PLATE X.

This shows the general shape or mass of a tree standing out in relief against the sky.

The tone of the paper represents the tree itself. The sky was done with a grey pastel.

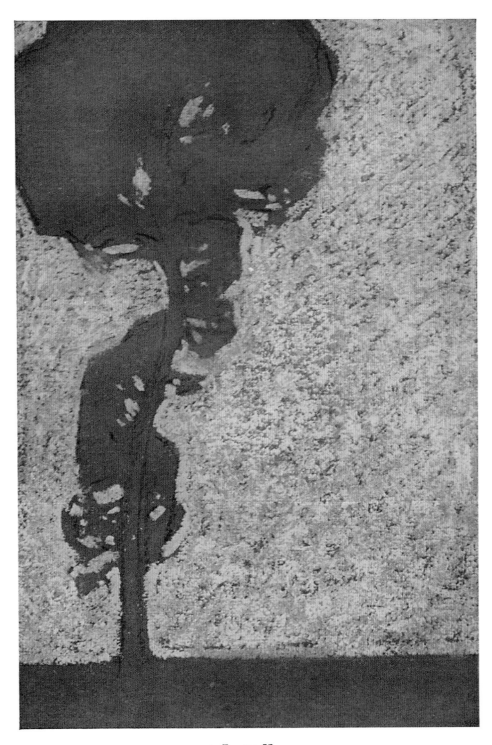

PLATE X.

COTTAGES.

PLATE XI.

Cottages treated in a similar manner to the first example.
A blue pastel was used for the sky.

PLATE XI.

TREES.

The group of elm trees in Fig. 1 is taken from Plate XVI. There the use of the light yellow pastel for the sky, in Stage I only, clearly

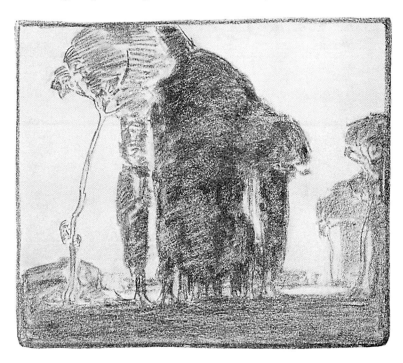

Fig. 1.

indicates from the very beginning the shape and character of the trees and the composition of the whole picture. It is advisable, when showing luminous interstices through trees, for the forms to be arranged with some consideration for design. The exercise also affords an opportunity of seeing the shape of branches and characteristic features in different trees.

37

FIG. 2 shows an arrangement of interstices of light through the trees.

FIG. 3 is the same group with badly arranged branches and patches of light.

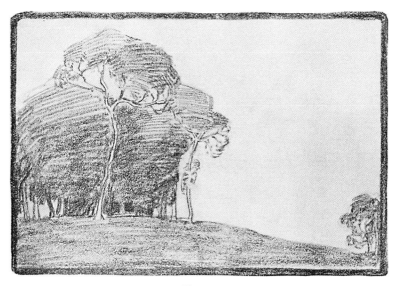

FIG. 2.

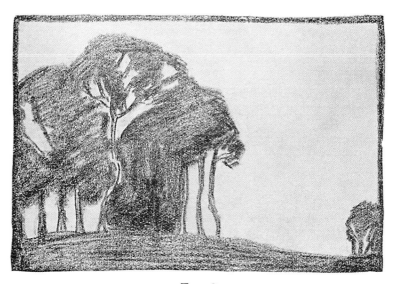

FIG. 3.

HILLY DISTRICTS.

FIGS. 4, 5.

It is generally noticeable in hilly districts that leading lines balance each other, and form a contrast with their opposing angles. The line AB, FIG. 4, is balanced by CD.

FIG. 5. Here the same idea is repeated in the distant hills.

40

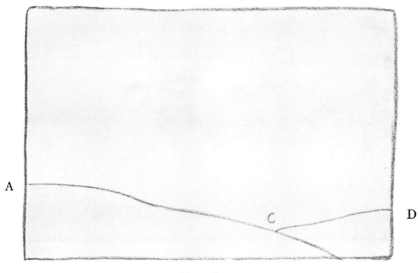

A C D

FIG. 4. B

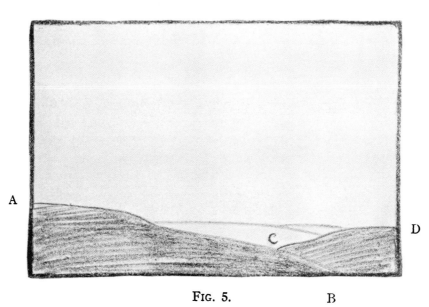

A C D

FIG. 5. B

FLAT DISTRICTS.

FIGS. 6, 7.

In sketching flat types of landscape, it does not do to place the horizontal line of distance half-way up in the height of the picture. The earth being darker in tone than the sky would make it appear as if the picture had been cut into two equal parts. A much safer plan is to place the horizon line at a distance from the base equal to about one quarter of the height of the picture or less, as shown in the sketch by the line AB.

The height of the trees can be far more clearly realised in flat countries when the horizon line is quite low in the landscape. There is a certain serenity and largeness of feeling in the simple contrast of tall trees standing at right angles to low-lying, flat ground. (*See* FIG. 7.)

A

B

FIG. 6.

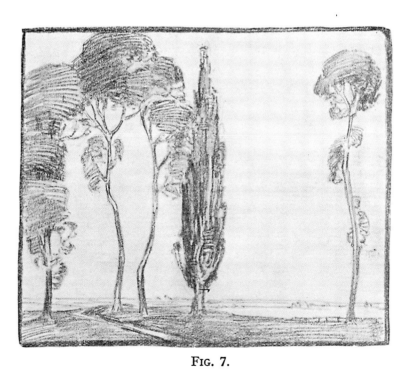

FIG. 7.

HINTS ON ARRANGEMENT.

FIGS. 8, 9, 10, 11.

It should help students who have little idea of composition or arrangement of landscape pictures to make a number of little sketches in pencil, or pen and ink, or any other convenient medium. This sort of thing can be done in spare moments to fill up intervals which otherwise might be lost. Any odd bits of paper will do.

In making compositions of trees, cottages, and other objects, it is inadvisable to place the same number of trees, etc., on each side of the picture.

FIG. 8 shows a bad example of spacing trees.

Here in FIG. 9 the same number of trees are used, but three are placed on the right of the picture, leaving one only on the left.

This design is evidently more interesting, as it gives variety and contrast.

Fig. 8.

Fig. 9.

Four trees were used again in Fig. 10. The one on the left was brought further into the foreground, while the three trees on the right were placed further away in the picture than those in the previous sketch, a contrast in the height of the trees being thus introduced.

Fig. 11 is spoiled by the tops of the trees coming immediately under the top line of the picture. It looks as if this line was being supported or propped up in its place by the three trees below. A much better way of dealing with the difficulty is shown in Fig. 12.

46

Fig. 10.

Fig. 11.

FURTHER SUGGESTIONS FOR COMPOSITION.

Figs. 12, 13, 14, 15.

These sketches show some suggestions for landscape composition. The dotted lines in Figs. 12 and 13 are placed to show how the contour of trees may help to lead the eye to other parts of a sketch.

48

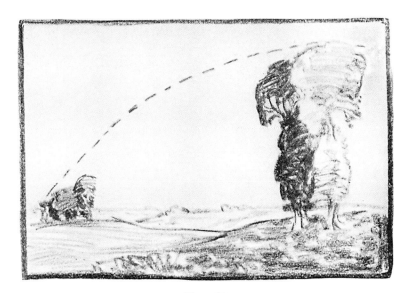

FIG. 12.

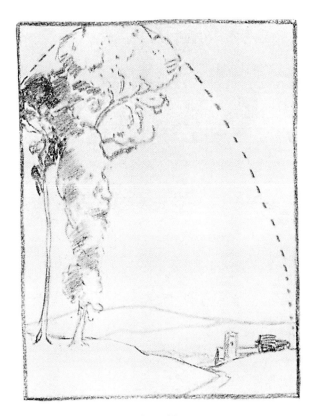

FIG. 13.

FIG. 14 conveys a feeling of height in the hills by showing very little sky, and because the dark clump of trees at the top of the hill on the left is cut off by the frame of the picture, leaving an uncertain amount of unrecorded height to be conjectured. The two trees on the right of the sketch are balanced by the dark clump at the top of the hill.

It would have been undesirable to use only the nearest two trees in the picture, leaving out the others placed high on the hill. In that case, the result would have been unfortunate in its effect on the totality of the picture, as the eye would then have been led, on account of their size, to the two nearest trees on the right, instead of to the interesting part of the picture—the hill with cottages and trees and the distant lines of hills.

In FIG. 15 the upper portion is connected with the lower by a beam of light flashing diagonally (and one may add, dramatically) from the dark tone of the higher to the same tone in the lower trees.

The descending shape of the highest black cloud enables the eye to convey to the mind that sense of continuity necessary in good composition.

FIG. 14.

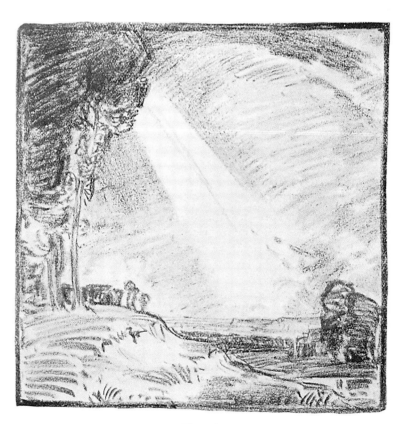

FIG. 15.

CHAPTER VI.

LANDSCAPE *(concluded)*.

Shadow Cast on White Wall.

Plates XII, XIII, XIV.

Simple drawings illustrating, in three stages, the shadow thrown by a tree-trunk on the surface of a white wall and ground.

Four pastels only were used.

Three progressive illustrations are given of this simple subject, showing clearly the means by which quite a direct method of doing landscape pictures in pastels may be acquired, whether these subjects are easy or complex.

First Stage. (Plate XII.)—The subject was sketched in with charcoal and strengthened with brown pastel.

52

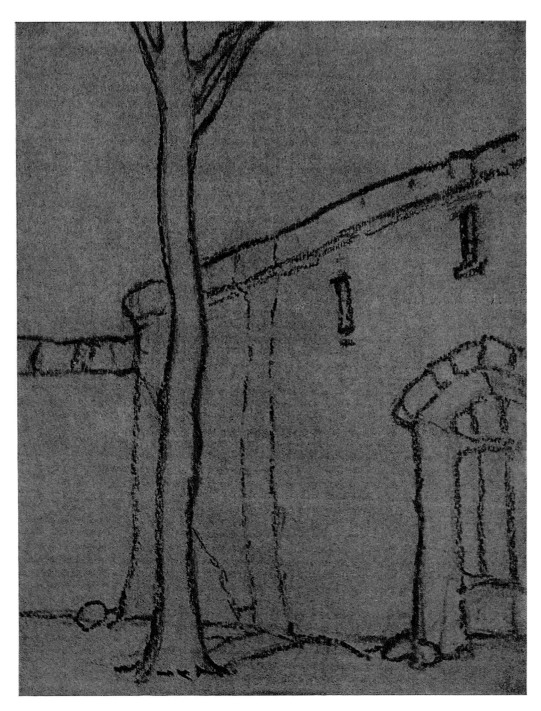

PLATE XII.

SHADOW CAST ON WHITE WALL

(continued).

PLATE XIII.

Second Stage. (PLATE XIII.)—The next work was the sky, which was put in quite flat with a grey pastel. This brought out the shape of the wall and the upper part of the tree-trunk into strong relief.

A white wall is often lighter than the sky, especially when in sunlight. Yellow ochre (fairly deep in colour) was therefore placed on that portion of the wall exposed to the sunlight, the tone of the paper being left to represent the shape of the doorway, small windows, and shadow of the tree-trunk on the wall and ground.

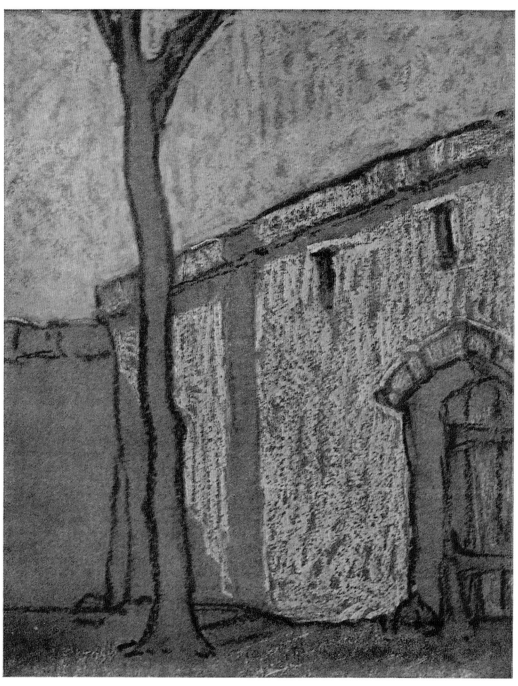

PLATE XIII.

SHADOW CAST ON WHITE WALL

(continued).

PLATE XIV.

Third Stage. (PLATE XIV.)—The outline of the tree was strengthened with dark brown pastel, and so also were the top of the wall and the door.

White, or very light yellow ochre, was used for the bright effect of the sunlight on the wall, intermixed with the darker yellow mentioned in the second stage. The shadows were deepened where they occurred.

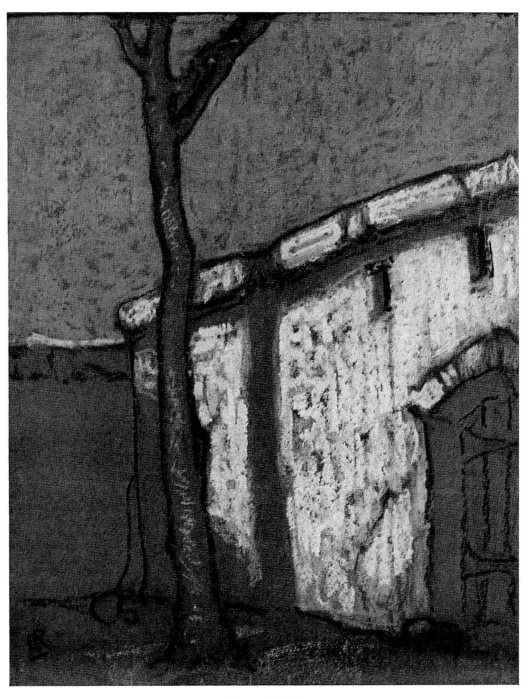

PLATE XIV.

ELM TREES.

Two progressive drawings of elm trees, to demonstrate the value of grey paper in landscape sketching.

Four pastels were used.

First Stage. (PLATE XV.)—The trees and foreground were sketched in with charcoal. Then the sky was put in with pale yellow ochre. The light between the branches and leaves of the trees requires careful study in relation to the design of the whole clump. (*See* "Landscape," Chapter V.)

Yellowish-green pastel was used for the light on the fields.

In the initial stages of a landscape, the picture should be quite clear in its composition and general proportions. It would be advisable to begin again if a sketch seemed unlikely to show a good foundation for further progress.

58

PLATE XV.

ELM TREES

(continued).

PLATE XVI.

Second Stage. (PLATE XVI.)—When the contour and the shadows of the trees in the foreground had been deepened by dark pastel, the middle-distant trees at once appeared further away, entirely in consequence of the alteration of tone values.

The brighter lights on the nearer field were then strengthened with the same coloured pastel as was used for the sky.

The final pastel, green, was used sparingly on the trees and field in the foreground. Certain grey papers require very little green pastel, for their effect is often closely allied to green.

PLATE XVI.

TREES AND WATER.

PLATES XVII AND XVIII.

Two progressive illustrations, showing the effect of trees silhouetted against the sky, and the treatment of water.

Four pastels were used.

First Stage. (PLATE XVII.)—The trees and landscape were outlined with charcoal or dark brown pastel.

Yellow ochre was used for most of the sky, and also a little yellow ochre was used for the reflections on the water and touches of light on the land.

PLATE XVII.

TREES AND WATER

(continued).

PLATE XVIII.

Second Stage. (PLATE XVIII.)—Grey and white were required for the sky and the clouds, and also for the reflections on the water. The shadows on the trees were deepened with black pastel, and so were those on the nearer fields.

A little grey was used for the slender trees behind the dark clumps in the foreground.

SUNSHINE.

Two progressive illustrations showing the passing effect of sunshine in a landscape.

Six pastels were used.

First Stage. (PLATE XIX.)—On cloudy days, with sunlight showing only occasionally through the clouds when they break apart, an effect such as this must be done with great rapidity. After the outlines of the landscape had been suggested, the light on the fields, trees, etc., was put in immediately, before the position of things became changed. Only two pastels were used to perform this stage.

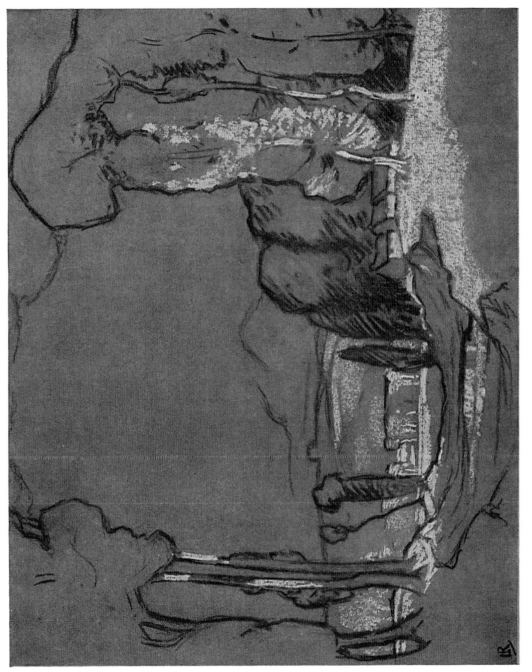

PLATE XIX.

SUNSHINE

(continued).

PLATE XX.

Second Stage. (PLATE XX.)—The main objective being now achieved, the sky was added, with the darker details of the trees, etc.

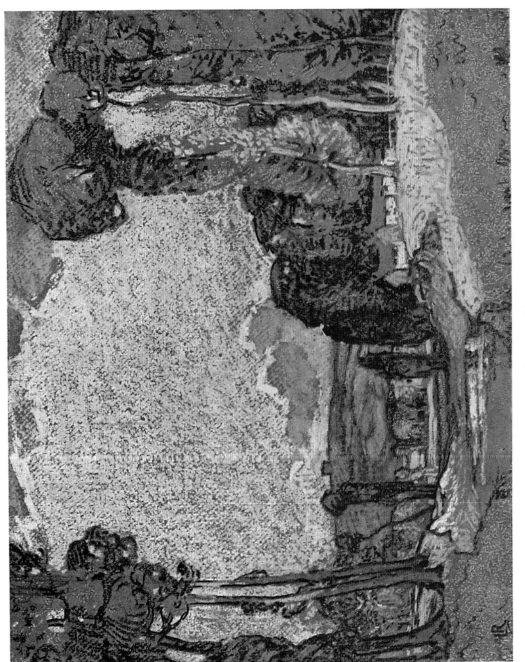

Plate XX.

A WHITE CANAL BRIDGE.

Plate XXI.

Drawing of a white canal bridge, showing its reflections on the water when the surface of the water is somewhat agitated by the wind.

First Stage.—After the outline had been completed, the chief prominent feature of the picture, viz., the white bridge, was put in, the portion in sunlight being rendered with light yellow ochre, and the shadow with grey.

Note that, on most coloured papers, to use white pastel only in order to get the effect of light on white walls would be to produce a cold, chalky appearance, without much body in it. Light proceeding from the sun carries some glow of warmth with it; a pale yellow ochre pastel, put on boldly, gives solidity, light, and warmth, all in combination. The white pastel, if needed at all, should be used sparingly —just enough to heighten the effect of the pale yellow ochre.

Second Stage.—Dark shadows, touches of green on the trees, suggestions of windows, doors, and other details in shadow were now added, but only to a limited extent, so as not to lose sight of the main idea of the picture.

In subjects of this sort, it is easier to do the water and its reflections last. If the bridge, buildings, and trees are correctly spaced, their reflections also will have a good chance of coming into their right positions.

PLATE XXI.

OLD HOUSES, FOLKESTONE.

PLATE XXII.

Old buildings, with their different-coloured surfaces, broken walls, cracks, patches of mildew, and other interesting shapes make admirable material for the pastel artist. Posters, advertising notices, and other printed matter on the walls of ancient structures are useful from the colour standpoint, as bright blue, orange, lemon yellow, and other hues, by contrast, accentuate the antiquity of the building on which they may have been placed.

In this drawing, the sky was put in first, and thus the contour of the buildings was made to stand out in strong relief against the light, and the general shape and proportions of the picture were clearly indicated. The next step was to use dark brown and black pastels, to show the structure and detail of the buildings.

Dark red, vermilion, green, yellow ochre, lemon yellow, orange, burnt sienna, and cobalt blue, were used to produce the finished picture.

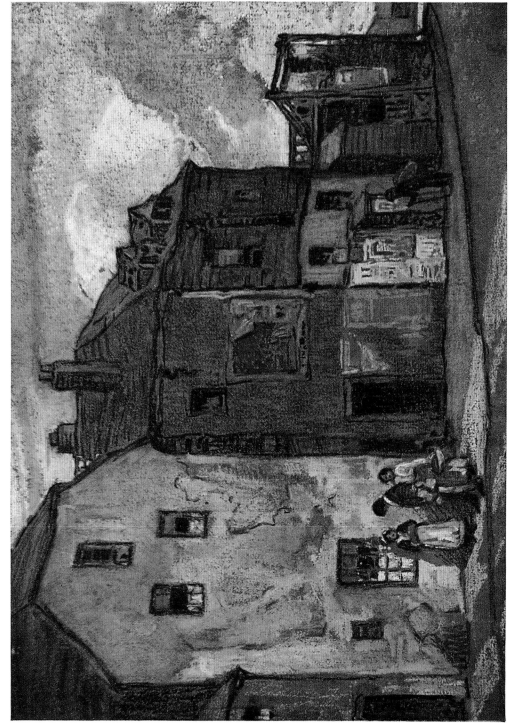

PLATE XXII.

STUDY OF STRAW IN SUNLIGHT AND SHADOW, WITH FARM BUILDINGS.

Plate XXIII.

This drawing illustrates particularly the power of pastels in representing brilliancy of light as opposed to shadow.

Definite and decided lines with the yellow pastel were needed to get the crispness and sparkle of the glittering light on the straw in the sunlight.

In many parts of the shadow in the nearer building, burnt sienna and orange were used to obtain the warm glow caused by the reflection of the straw, with a judicious use of grey pastel to cool and tone it down in places.

First Stage.—Bold and vigorous outlines with the dark brown pastel were helpful in bringing the nearest portions of the building well to the front. For the sky, which is low in tone, blue, grey and a little yellow are needed; yellow ochre is used for the straw in the sunlight, and the dark brown pastel for the roof shadows, wall, and ground. A touch of blue is wanted for the figure in shadow.

Second Stage.—White, lemon yellow, and pale yellow ochre are required for the lightest part of the straw; dark grey in places for the shadows; deep blue and grey for the distant hills; yellow, pale green, etc., for the stone support or column in front.

74

PLATE XXIII.

A BREEZY DAY AT WATCHET, SOMERSET.

PLATE XXIV.

The sketch shows the incoming tide beating against the harbour walls and dark rocks on the shore.

It was done in about thirty minutes. The rapidity of pastel was of paramount importance in getting the passing effect of the light shining on the water and the harbour walls; the artist had to finish the sketch quickly in order to escape from the rising tide.

First Stage.—The light on the water, harbour-walls, and rocks was indicated. Then the tone of the rocks was deepened, and grey was added for the sky.

Second Stage.—The light on the waves dashing against the walls, etc., was strengthened, and a little blue was added and intermixed with parts of the grey sky.

For the foam of the water in shadow, grey was used, and also a little light yellow ochre.

76

PLATE XXIV.

CHALK CLIFFS ON THE SOUTH COAST.

PLATE XXV.

Pastels are especially good for the texture, or surface quality, of white chalk cliffs.

Cliffs, as much as any other subject, need strong, robust outlines to retain their shape and structure, particularly in the earlier stages of the picture.

First Stage.—The lighter portion of the cliffs was done first with pale yellow ochre.

The remarks about white walls (*see* PLATE XIII) are applicable to this subject also.

Second Stage.—The sky, the darker cliffs in the distance, and the foreground were next done. Touches of green for the high parts of the cliffs and for the rocky substances on the beach were then added.

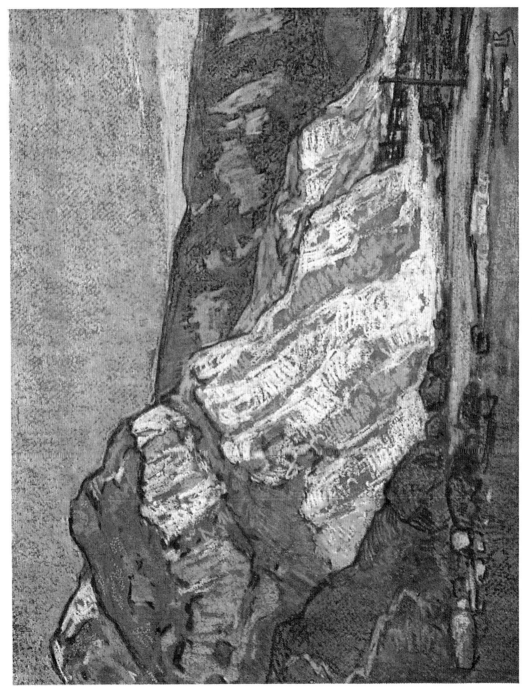

PLATE XXV.

CANAL BARGES AT BRENTFORD.

PLATE XXVI.

This picture was done when the evening sun was strongly illuminating. Reflections on water present interesting but difficult problems, particularly if the water is not stationary. The quickness of pastel was very useful in obtaining the transitory effect of the evening sunlight on the buildings.

First Stage.—The sky was done first to help the roofs and shapes of the buildings to appear on the paper. Next, the carmine and orange pastels were used for the lights on the house and the reflections on the water; deep blue for the shadow under the bridges, the sides of the canal-boats and the reflections; orange-brown for the hay in the barges; warm grey for the road and for the buildings in places.

Second Stage.—White, lemon yellow, and grey were applied to the sky and the water; bright yellow and white to the buildings; black, green, etc., were required for the figures on the road.

A little purple and light blue were added to different parts of the picture.

The chief thing to remember in evening sunlight pictures is to get a sensation of warmth by choosing the colours likely to produce that effect, whether in sunlight or shadow.

80

PLATE XXVI.

THE QUARRY.

PLATE XXVII.

This picture possesses strong contrasts: light *versus* dark, warm glowing colour opposed to cool tints, the vertical trees breaking directly across the distant horizontal line of hills.

A good sprinkling of dark brown pastel has been successful in uniting various opposing colours without losing the strength of their different contrasts.

The title "The Quarry" is brought to the mind of the spectator, since the leading lines in the composition of the picture are arranged so as to lead the eye directly to its most prominent feature, viz., the quarry, which, being placed centrally in the picture, made the composition considerably less difficult to manage than would otherwise have been the case.

Plate XXVII.

CHAPTER VII.

FIGURE.

In dealing with the Figure it must first be clearly understood that the technical difficulties are considerably greater than in any of the other subjects already dealt with. An eighth of an inch or so may not necessarily matter in the shape of a tree or the size of a leaf: not so with the width of an eye or the length of a nose. Until a face or a hand can be thoroughly well drawn with a pencil, any attempt to use pastel will only prove futile and disappointing. However sketchy and indeterminate many a fine pastel may seem, the knowledge of the figure required is just as great.

It is no part of this book to give hints on drawing—the requisite power is presupposed. Nor will any rules for colour be laid down, because not only are the local colours different in every figure, but the apparent colours depend so much upon the intensity of the light and the colour and tone of the surroundings. All that is attempted here is to point out and illustrate different styles: in other words, to show the various ways in which pastels may be successfully used; and, especially, to indicate the suitability of certain styles for certain subjects. Every artist will prefer some style to all others, but it would be absurd to attempt to impose it upon others. Great work can be done in any style by a great artist to whom that style appeals, always providing that he understands and appreciates the essential characteristics and limitations of the medium.

HER LADYSHIP.

Plate XXVIII.

This is the simplest form of pastel drawing, one that was used with charming effect by Sir Peter Lely and other artists of that time. Practically all the form is indicated by the outline and slight shading in dark brown crayon; the colours merely serve to suggest the flesh and lips, and separate the drawing from the background. Though apparently simple, it is not so easy as it seems. The drawing must be without flaw and exceedingly delicate, and the shading should suggest much subtle form not actually drawn. The colour must be laid on with absolute certainty—one false stroke may spoil the whole work. Hard or semi-hard pastels should be used, and especial attention paid to the direction of the strokes. To save disappointment and waste of time, it would be well to make a tracing of the outline, and, transferring it two or three times on to separate pieces of paper, experiment boldly with the colours before attempting to use pastel on the carefully finished outline.

This style is obviously best suited to the female figure.

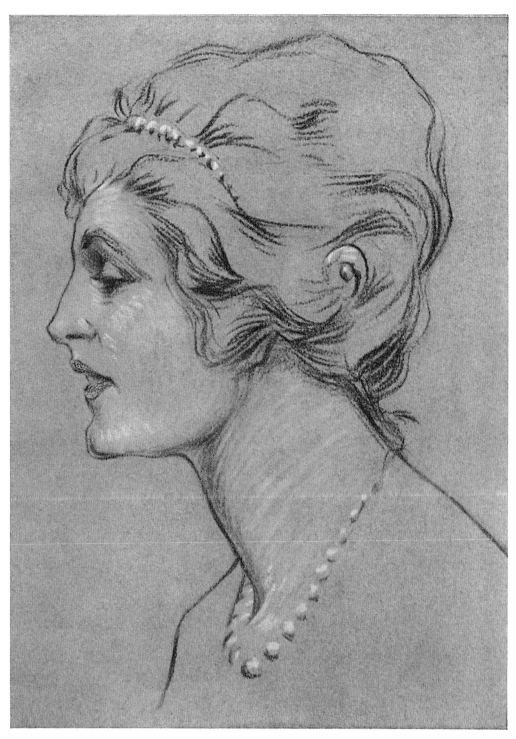

Plate XXVIII.

"E. J. H."

Plate XXIX.

In this example the method is much the same as in Plate XXVIII, but the effect is far different. Only a few more colours are used, and the outline is still relied on for most of the shape. The pastels, however, suggest not only the local colour of the face, but also the effect of light upon it. But they only *suggest;* there is no attempt made to realise colour values.

The drawing is altogether more vigorous, as befits the subject.

A few points should be particularly noted.

(*a*) Only the sharp point is used, so that semi-hard pastels will be found preferable.

(*b*) The strokes are kept more or less separate, particularly in the darker portions, where the paper more nearly approximates to the colour of the face.

(*c*) The direction of the lines is always such as to emphasize the form.

(*d*) The colour of the paper is specially chosen to suit the subject.

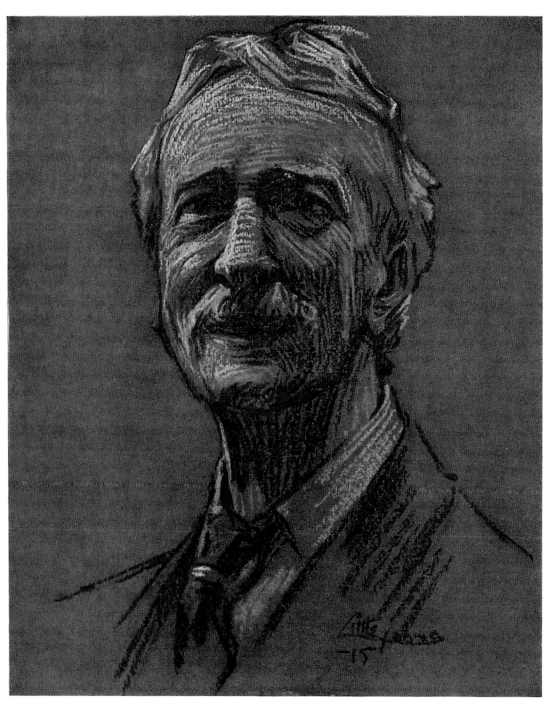

PLATE XXIX.

THE JOVIAL PHILOSOPHER.

PLATE XXX.

However different the effect, the method employed here is merely an extension of that used in PLATE XXIX. The outline has now become of secondary importance, emphasizing the form obtained by the pastel, instead of being itself emphasized by the colour. But the point is still used throughout, except on the background, which is done with the side of the pastel. Also, the colours are sometimes superimposed, though not to any great extent. The paper, it is important constantly to keep in mind, is still largely relied on as a modifying factor.

The preliminary outline must be drawn lightly in charcoal instead of firmly in black chalk as before.

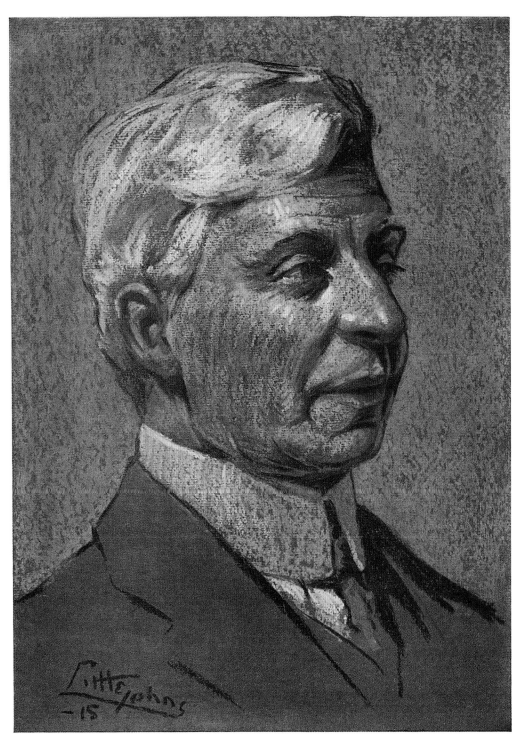

PLATE XXX.

A VOLENDAM FISHERMAN.

PLATE XXXI.

This and the next example illustrate very forcefully two methods of treating faces with strongly marked features. In both cases the heavy outline and markings of the face are drawn first; and then the colour is placed in the spaces between these lines. In this plate these spaces are almost entirely filled up, and colours are occasionally superimposed in the light parts.

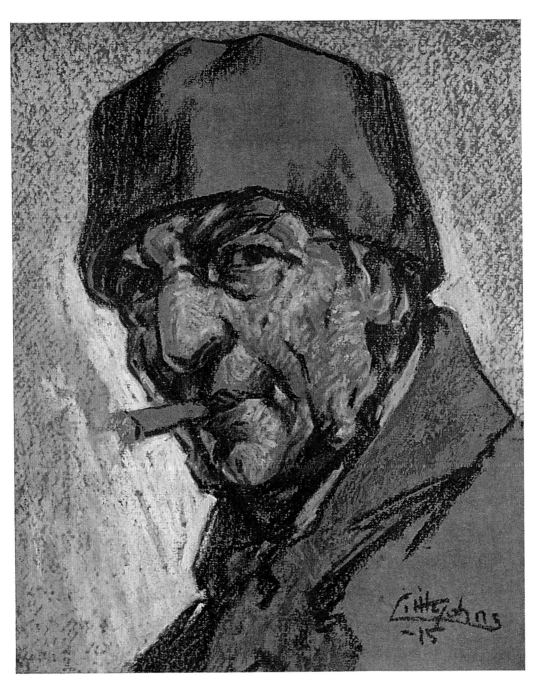

PLATE XXXI.

" EIGHTY."

Plate XXXII.

In this plate, where, in contrast with Plate XXXI, most of the face is in shadow, the paper is responsible for a large proportion of the tone; the lights are supplied with vigorous touches of strong colour, each stroke separated from the others. The slight modification of the paper on the left side of the face is produced by dragging the side of the pastel lightly over the surface.

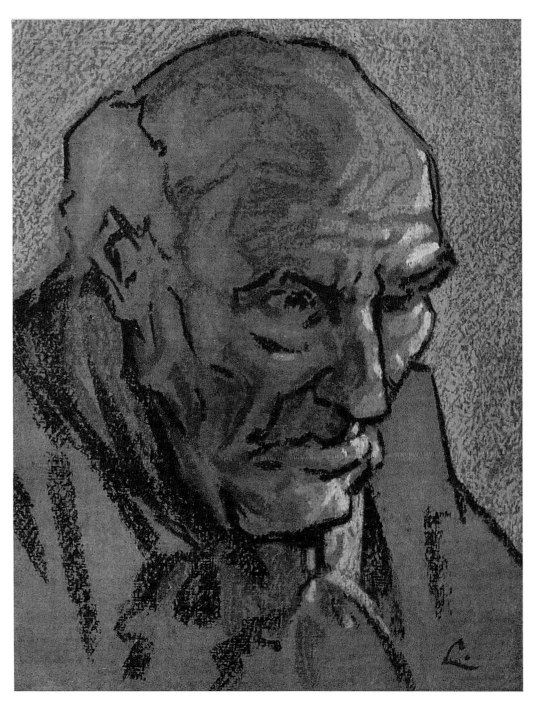

PLATE XXXII.

THE PROFESSOR.

Plate XXXIII.

This is distinctly in the modern manner. Its inclusion is not so much on account of any merit it may possess, but to show how easily brilliant effects can be obtained by placing colours close together but not overlapping. When one colour is placed on another, the darker is bound to lower the tone of the lighter, and the duller colour dim the brilliance of the brighter one. The ultra-modern painters who aim at this class of effect generally paint in oils. By adopting pastel, they would be able to achieve more striking results with greater ease and in less time; and, what is more important, the method is clearly better suited to pastel than to any other medium.

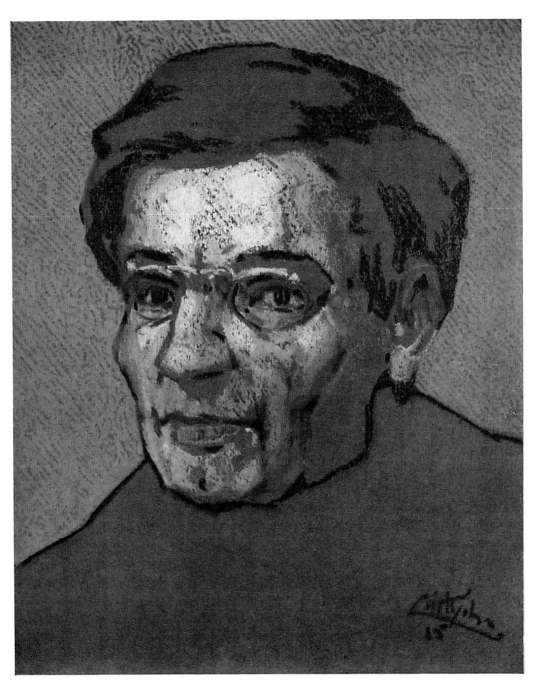

PLATE XXXIII.

ABSENT.

PLATE XXXIV.

Hitherto, all the examples have been studies of heads with or without a flat background; and executed with no thought of making a complete figure picture, where drapery, hands, background, etc., form essential parts of the design.

This example shows the simplest means of making a composition —a means peculiarly suited to pastel—which would not look complete in any other medium. The paper chosen (Reeves's Pasteloid) was so beautiful in itself that it seemed a pity to cover it. The technique employed was also largely influenced by the paper. When the side of a pastel is lightly rubbed across it, the grain becomes evident and gives the drawing an individual quality in the same way as a piece of Michellet does. In consequence, therefore, of these two facts—viz., the colour and the texture of the paper—the background was left untouched, and the table and photograph-frame were suggested only by outline and shadow; and, wherever possible, the side of a short piece of pastel was used instead of the point. The effect is in harmony with the subject—artless simplicity.

PLATE XXXIV.

MATILDA.

Plate XXXV.

This example is a complete contrast both in manner and in intention. The aim is twofold—to make an ornate decoration as well as to paint a portrait—an aim strenuously advocated by a certain school of modern painters. The "all over" nature of the composition was insisted upon in several ways. The background was treated as firmly as the other parts, and brought into the same plane as the rest of the picture. It was also "built into" the composition by its definite relation to the "line" of the figure. The strong black markings on the dress were carried round the face and hair. The face was treated in a rather flat manner, so that it should not stand out from the rest.

It is commonly supposed that this method is adopted by those who find more realistic representation beyond their powers. As a matter of fact, the achievement of a really successful picture in this style necessitates the possession of a sense of the decorative which is not by any means the common property of all artists.

But the main point, so far as the purposes of this book are concerned, is the comparative ease with which this style, depending so largely upon definite lines and broken colour, can be effectively rendered in pastel.

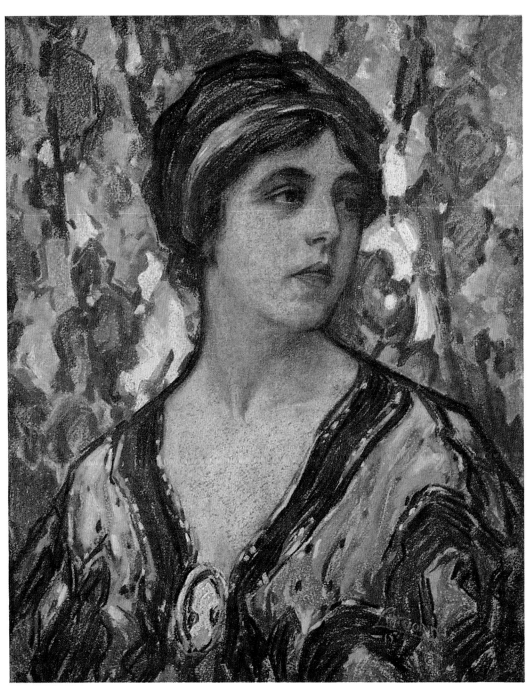

PLATE XXXV.

MAISIE—A SKETCH.

PLATE XXXVI.

This light, inconsiderable sketch, which was done in a few minutes, is included to show how quickly the essential features of a figure subject can be caught. By this means, however, a certain evanescent charm can be suggested which is never altogether retained in the more complete rendering. But it requires great powers of draughtsmanship, a rare faculty for the choice of essentials, and a freedom of handling which only comes of continuous practice.

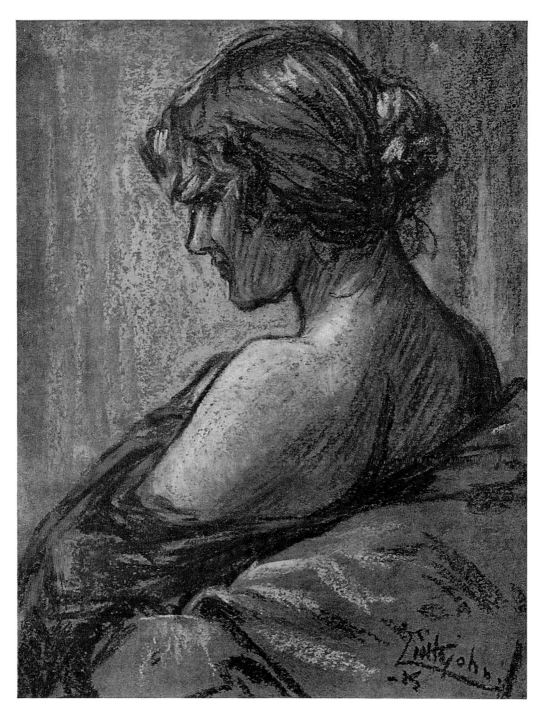

PLATE XXXVI.

THE GREEN SHAWL.

PLATE XXXVII.

This illustration is, technically, the most elaborate of all. Some parts—the face and the glove—had an undertone rubbed in, entirely covering the paper. The background, on the contrary, had only a comparatively few loose touches of colour, the general tone being supplied by the dark grey-green paper. In fact nearly all the methods indicated in former illustrations have been used here with the intention of producing an effect of extreme richness. The style is much more realistic than that of the preceding illustrations, but not completely so. That popular form of pastel portrait which attempts to imitate exactly all the parts of the picture, such as the texture of cloth for instance, by rubbing an undertone over every part, may possibly result in greater verisimilitude, but, as a work of art, will almost inevitably be a failure. Indeed, the method, or rather the combination of methods, used in this example can only be safely adopted by the experienced portrait painter; and the result even then is not likely to be as satisfactory as that produced by more simple and direct methods.

But the student should give every method a sufficient trial before finally deciding which suits him best.

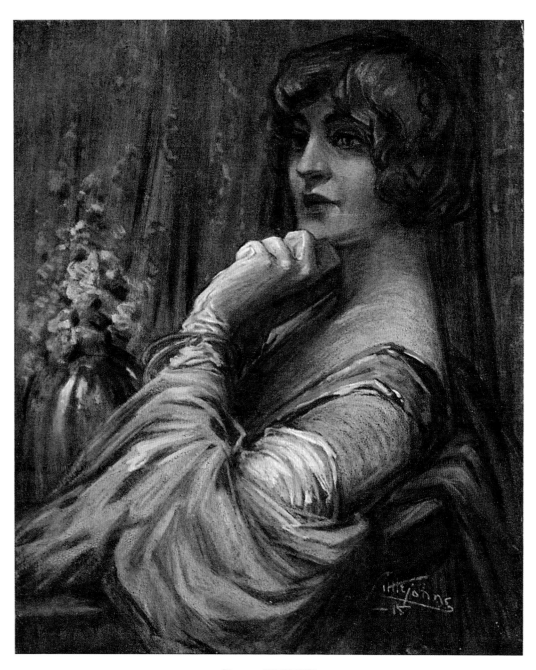

PLATE XXXVII.

THE DUTCH BABY.

PLATE XXXVIII.

A quick sketch of figures in sunlight, done in the same manner, for exactly the same purpose, as in PLATE XXXVI. There was no intention to make a complete realistic representation, but rather to suggest the colour, the composition, and, more particularly, the effect of light.

The whole subject was first drawn with a crisp outline of dark brown. Then the tone of the white houses, green door and windows, etc., in view was put in quite flat, so that the darker parts—the figures and trees—stood out as a silhouette of brown. Afterwards, by using, very lightly, pastels of almost the exact local colour of the drapery, tree-trunks, etc., the effect of these objects in shadow was produced. A few brilliant lights, a few touches of emphasis and detail to give verve and character—and the whole picture was completed!

For those who desire to paint landscape in which figures play a prominent part, this method is of the utmost value in overcoming the greatest difficulty in the treatment of such subjects; viz., that of making the figures take their positions as integral parts of the picture.

106

PLATE XXXVIII.

THE VERMILION GOD.

PLATE XXXIX.

The last paragraph of the Note to PLATE XXXVIII applies with even greater force to this, the last example. Here the aim is solely decorative; that is, to produce a composition of form and colour as a complete end in itself.

This is not the place to examine the claims of such pictures as works of art, but only once more to emphasize the peculiar fitness of pastel for the purpose. It may be, indeed, that pastel, which for so long was deemed only suitable for portraiture, but has now vindicated its position in landscape, will finally come into its own in the decorative sphere.

Except in the case of the dusky figure, the influence of the paper is less marked in this than in most of the other illustrations, because the pastel is laid on heavily in order to secure the full value of each colour. In this class of subject and treatment a comparatively large range of the richer pastels will be required.

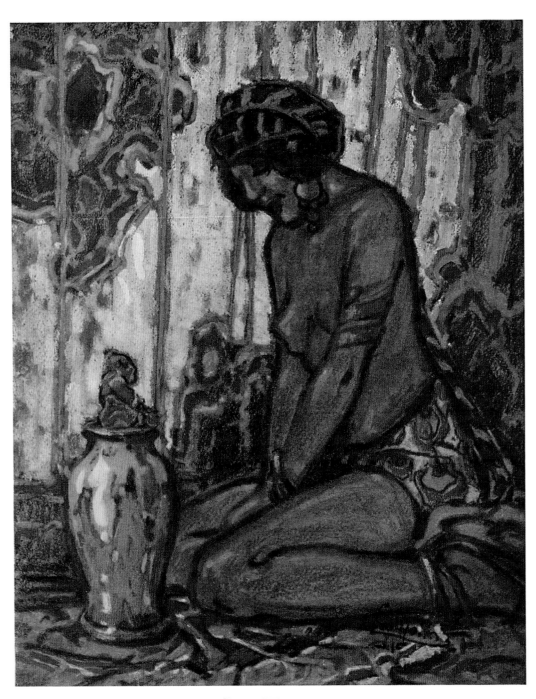

PLATE XXXIX.

CHAPTER VIII.

THE PRESERVATION OF PASTELS.

THE comparative unpopularity of pastels is due to two widespread misconceptions: first, that they are impermanent; secondly, that they cannot be preserved from injury. As to the first, there should be no doubt whatever. All pictures fade. Under the action of strong light, water-colours will almost entirely disappear. Most oil paintings undergo a change in a few months: they are affected by time, oil, impure air, the ground on which they are painted, the quality of the pigments, and the method of painting. Now, in pastel, just as in oil and water-colour, certain colours, such as chromes and emerald green, are fugitive, and the wise artist leaves them out of his palette. Otherwise, the colour of the best class of pastel undergoes practically no change. Numerous severe tests have proved conclusively that in this respect pastel is unrivalled. This question is dealt with more fully in the chapter on materials.

The prevalence of the second misconception is largely the fault of pastellists themselves. If a picture is composed of many layers of chalk plastered on one another, it is obvious that every time it is shaken some of the chalk will fall off. But there is no need to abuse the medium by such an unsuitable method, when better effects can be produced by using an amount of pigment which will adhere to the paper, provided the picture is treated with as much care as one expects to give to, say, a piano. A damp wall is as injurious to a pastel as to a water-colour or print. But why hang a picture on a damp wall? Any risk of ordinary slight dampness can be obviated by placing two little pieces of cork behind the frame, where it would otherwise touch the wall. Careless mounting and framing have spoiled many a pastel, but can easily be avoided if the following few simple suggestions are carried out.

The paper should be perfectly flat. If it "cockles" and some parts touch the glass, those parts will smear and leave a layer on the glass.

When the picture is to be framed as if it were an oil painting,

and particularly if it is a large one, the paper should be strained on a canvas stretcher. Between the pastel and the glass there must be, of course, a "slip" of about a quarter of an inch. And to prevent the possibility of accidental pressure from behind, the back of the stretcher should be covered with a piece of stiff cardboard.

But when the picture is to go into a light frame with a mount, like a water-colour, the matter is not so simple. After many experiments the writers have found the following plan satisfactory—

Paint the pastel on a piece of paper which has no trace of a "cockle." Lay it face downwards on a perfectly flat clean surface (such as a table), and completely cover the back of the paper with thin paste or glue. Lift it very carefully and place it in position, face upwards, on a piece of stiff cardboard of exactly the size of the rebate of the frame. Put a drawing board, not less than the size of the cardboard, on the top and subject the whole to pressure under a heavy weight till quite dry. Unless the picture is heavily painted it will be found that, although a little of the pastel has adhered to the drawing board, no perceptible change has taken place; and in any case very little touching up will be necessary.

The mount should be very deep; the variety known as a "sunk" mount, which any competent picture-framer can make, is certainly the best. With a backing of stout strawboard the framed picture will defy injury if treated with reasonable care.

But what, at first thought, seems to be a far more real difficulty, is not how to preserve framed pastels, but how to deal with the accumulation of sketches, which soon run into hundreds and are constantly needed when making complete pictures. Most artists are so accustomed to leaving their canvases against a wall or throwing their water-colours into a portfolio that the thought of having frequently to handle fragile sketches, which one smear would ruin, appals them. Here, again, the difficulty is not so great as it seems. The chief point to remember is this: that if the sketches are slight, as nearly all good sketches are, they will not be detrimentally affected by being pressed together, if the pressure is even and there is no rubbing. A little pigment may come off, but the effect will not be noticeable; anyhow, the usefulness of the sketch cannot possibly be impaired. But the slightest smearing may be fatal.

Now, that simple fact suggests several ways of avoiding accidents. Here are three—

1. Pin the sketches on a wall, or a clean canvas, or a drawing-board, face downwards.

2. Place them between the leaves of a book of clean paper with stiff covers.

3. Put them in *passe-partout* bindings, and see that they press tightly against the glass.

In addition to his sketches, the energetic pastellist will soon get together a larger number of finished works than he has frames ready to take ; and, unless some very definite plan for their care is adopted, they become a source of continual apprehension. Those which are strained on canvas stretchers should have a piece of cardboard pinned over the picture and another over the back of the stretcher. The others should be mounted in the manner described on page 182 and pinned face inwards to a clean canvas or drawing-board.

But, it will inevitably be asked, why not save all this trouble by fixing both sketches and pictures ? This is a matter that demands the fullest consideration. The authors have thoroughly tested most of the highly recommended fixatives obtainable, and have been regretfully forced to the conclusion that no fixative has yet been invented which does not to some extent cause deterioration. Indeed, it seems inevitable, and for two reasons. In the first place, moisture of any kind changes the colour of all pastels, and, in addition, changes the colour of some more than others. This, however, reduced to a minimum, is inconsiderable, and to some extent can be allowed for when painting. But the second reason is more formidable. The distinguishing charm of pastel is the " bloom " on its surface, caused by minute particles of loosely attached chalk dust, each reflecting a tiny light and throwing its own minute shadow. Now, to fix a pastel every particle must be completely covered with the fixative and thereby stuck to the surrounding particles. This, inevitably, must alter the general appearance of the surface. At any rate, we have not yet discovered a fixative which perfectly preserves that dry, crisp, crumbling quality which pastel alone possesses, and which is too precious and distinctive to be destroyed. After the most careful treatment with the best known fixatives, the picture looks as if some of the surface had been blown or washed away.

Nevertheless, some fixatives are better than others, and the injury caused by the best is astonishingly small. The two we can most highly recommend are Ferraguti's, and Georges Bertrand's, both of which are supplied by Messrs. Lefranc. The latter is a recent invention of the well-known French pastellist whose name it bears, and differs from others in that it is composed of two separate liquids

113

which have to be applied in turn. Compared with the usual fixatives, the success of both is quite surprising, and if the thicker parts (high lights for instance) are gone over after the first fixing and fixed again, the result varies only slightly from that of the unfixed drawing.

It is essential to have a very good fixing apparatus. The ordinary spray diffuser will not do at all, because the vapour must be exceedingly fine and the flow continuous. Lefranc's Fixing Apparatus, No. 1417, is the best we know.

Apart from the purpose of preservation, one important use of fixatives should be borne in mind, viz., that it enables one colour to be laid upon another without merging, thus producing a crispness and brilliance often needed in the finishing touches.

CHAPTER IX.

MATERIALS.

WITH the object of saving the student much wearisome waste of time, the authors have tested most of the materials for Pastel Painting which are sold by Artists' Colourmen in London, and this chapter gives the results of their investigations.

1. PASTELS are usually made in three degrees : soft, semi-hard, and hard. In the vast majority of instances, the soft are distinctly to be preferred. In Figure the two harder varieties are sometimes essential when the work is small and highly detailed, as, for instance, in eyes, nostrils, and delicate outlines. But they should only be used when they cannot be done without. As the student attains to mastery the need for them will decrease. With the exception of PLATES XXVIII and XXIX in the Figure section, they have not been used in any illustrations to this book.

Pastels are made in some six or seven hundred tints, but many of them are so nearly alike as to cause confusion. Not half of them are conceivably necessary. In no case have more than twenty been used in any one of our illustrations, but, of course, not always the same twenty.

No one can say exactly what colours any one else will need; each must experiment for himself. So much depends upon the temperament of the artist : whether he is attracted by the greyness of things or is fascinated by brilliance ; whether he is moved to express subtle distinctions or strong contrasts. In any case, it is of little use relying upon the boxes of "selected" pastels issued by the makers. The best way is to begin with a few, exploit their possibilities, and add to their number as the power to use them increases. But it would be advisable, from the first, to have a chart showing all the colours supplied by the maker.

2. PAPERS AND CANVAS.—There is a large selection of suitable papers to be obtained, and, as the tone, colour, and surface so greatly influence the character of the work, the pastellist should be constantly experimenting. For it will be found that certain papers are especially suited to certain subjects and styles. Generally speaking,

a rather smooth surface is preferable for quick sketching, and the rougher varieties for richness in more elaborate work. For most subjects a warm tint is better than a cold one. The authors find that a medium-toned greyish brown suits more subjects than any other. Some of the ordinary packing papers are as good as anything sold for the purpose, and are much cheaper. But nearly all cheap papers tend to "cockle," and must be strained before using. The celebrated "Canson" papers, which can be bought anywhere, are as good as, if not better than, any other paper made.

Specially prepared canvases can also be obtained, but in most cases it is necessary first to rub pastel all over the surface to get a suitable tone to work on. This procedure is not recommended. There is nothing to beat a suitable paper.

3. SKETCHING-BOXES.—So far as we are aware, there is no completely satisfactory sketching-box sold by any firm in London. The ordinary white-wood box is too fragile, and is only intended to keep pastels in, not to carry them about in. There is, however, a box called the "Cedrate," of much the same pattern, which is quite strong and light, and has a detachable lid. But what is really required is a box so made and fitted that both pastels and sketches can be carried without shaking. Pastellists who do much sketching would save themselves endless irritation by having a box made like

116

the adjoining illustration. The general shape is similar to that of the ordinary oil box. The paper is carried in the cover, and pinned to the hinged flap when in use. A sufficient number of sheets must always be carried so that when the flap is closed they are quite tightly pressed together and cannot move about. The pastels are kept from moving by a thick piece of felt, which, when the box is closed also presses tightly against the flap. The side of the felt which touches the pastels is padded with cotton wool.

It is hoped that some enterprising artists' colourman will produce a box on these lines.

4. WHERE TO BUY MATERIALS.—Nearly all the requisites for pastel painting sold in England come from France, where the art is practised to a far greater extent than in any other country.

Among the best English makers of high-class pastels are Messrs. George Rowney & Co., Percy Street, W., and their enterprise deserves to be better known. Both in quality and range their pastels are excellent. There are over four hundred shades, including exceptionally beautiful greys, olive greens, and browns. Unlike some makes, their darkest shades are not in the least gritty or brittle. Permanence of colour has been most carefully considered in their manufacture, and we find that they stand the severest test of strong light remarkably well.

The " Pasteloid " papers of Messrs. Reeves & Sons, are some of the best made. There are twelve tints, ranging from pale grey to nearly black. The surface is fairly smooth and has that delightful grain referred to on p. 98. The paper is thick, and can be used without straining.

Messrs. Madderton & Co., make a specialty of brown paper in sketch books and separate sheets. For sketching, nothing better could be desired.

" Canson " papers (royal size) can be obtained anywhere.

Of the French makers the two best known in England are Girault and Lefranc. Girault's pastels are hand-made, and claim superiority on that account. The authors have used them a good deal for several years and can unreservedly recommend them. They can be obtained of Messrs. Lechertier Barbe, Jermyn Street, W., who also keep nearly all the makes sold in this country.

Messrs. Lefranc are the largest makers of pastels in the world. Their range of colours is enormous, and contains a unique variety of subtle greys. The quality throughout is excellent. In addition to the

usual three grades, they supply a fourth called "permanent," which excludes all pigments which are in the slightest degree fugitive; it is doubtful if the power to resist the action of strong light could be increased. Sample pattern cards of each grade can be had—a great convenience when ordering, as every pastel is numbered.

At their London branch, Bird Street, Oxford Street, W., all requisites may be obtained; they hold a varied stock of suitable papers and canvas. Among these may be mentioned a continuous felt paper, five feet wide, in three shades, and a delightful velvet paper in four shades. They also have a velvet canvas, in shades similar to those of the velvet paper, particularly suitable for large pictures.

When using canvas, it is very important to remember that after a while it will probably slacken and come into contact with the glass. If the wedges are hammered, the shock may disturb some of the delicate powder on the surface of the work, on which so much of the charm of the drawing depends. To meet this difficulty Messrs. Lefranc supply a special wedge—a clever contrivance which stretches the canvas by means of a screw.

Short of a complete sketching outfit like that described on p. 116, a combination of Lefranc's "Cedrate" Box and Sliding Drawing Frame is a very good substitute. The box is strong and has a detachable lid which can be removed at once. The drawing-frame is light and holds several sheets of paper without the possibility of movement, and, having no straps or bands, cannot easily get out of order.

The same firm supply several fixatives, including Georges Bertrand's, referred to at length in Chapter VIII.